This book belongs to:

River June & Whitley Roo

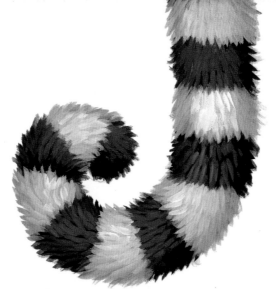

Whose Tail on the Trail at Grand Canyon?

by Midji Stephenson Illustrations by Kenneth Spengler

GRAND
CANYON
ASSOCIATION
INSPIRE. EDUCATE. PROTECT.

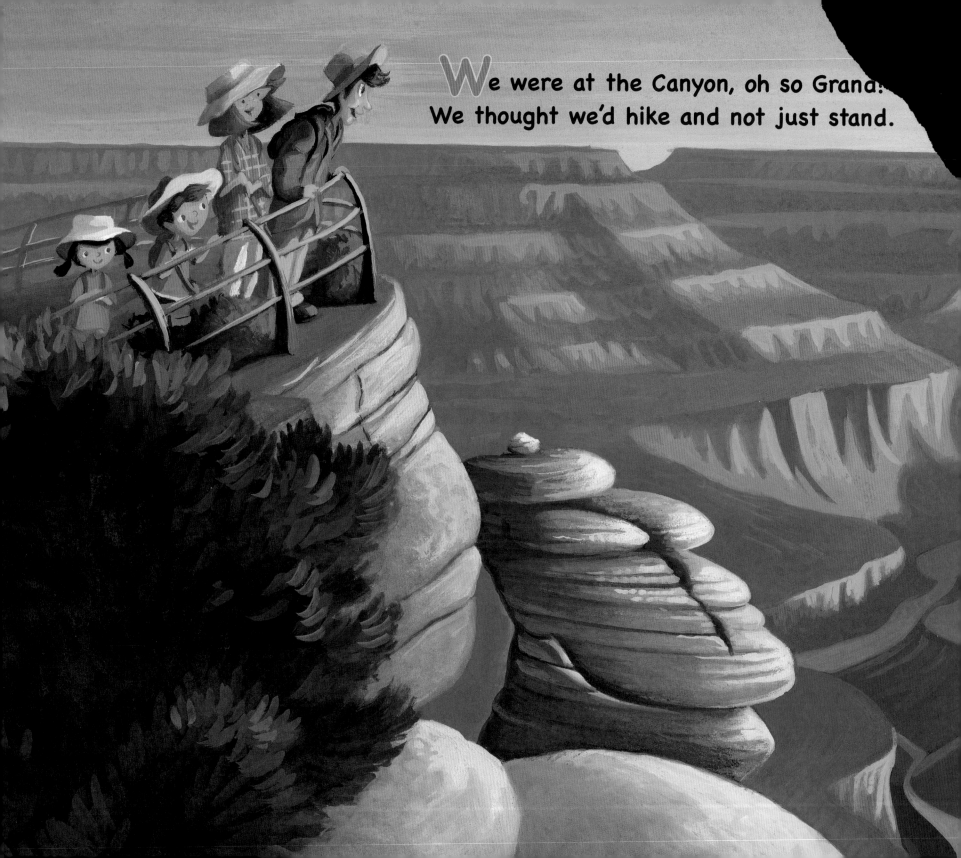

We were at the Canyon, oh so Grand!
We thought we'd hike and not just stand.

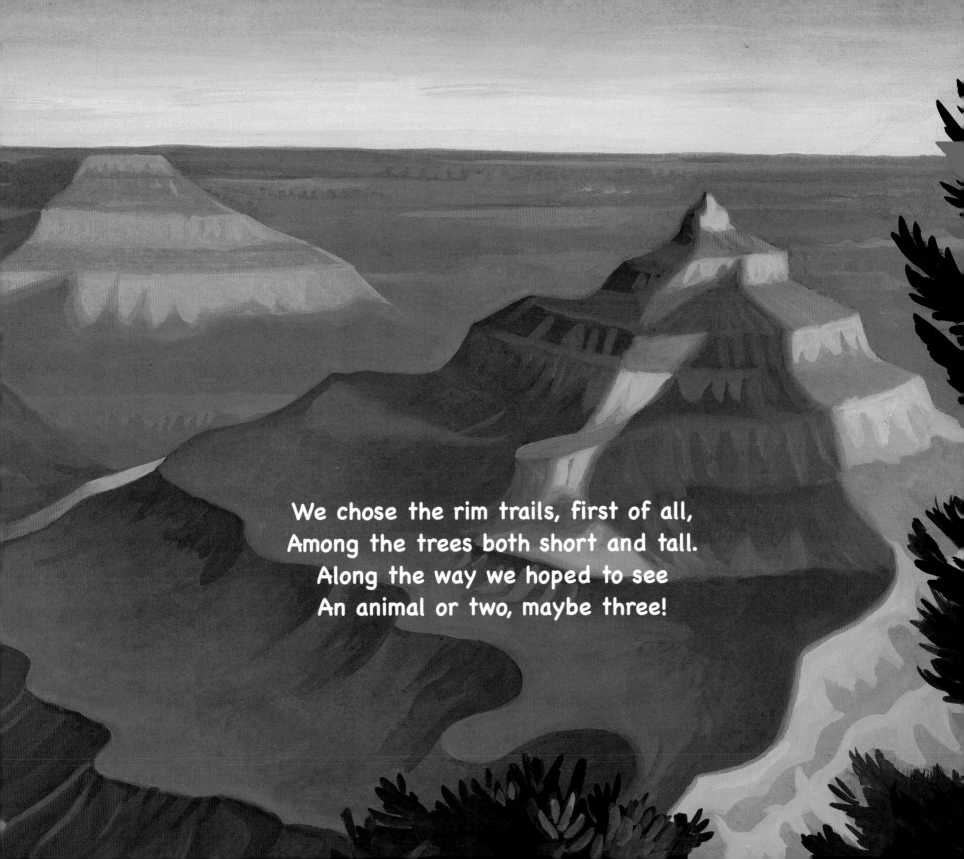

We chose the rim trails, first of all,
Among the trees both short and tall.
Along the way we hoped to see
An animal or two, maybe three!

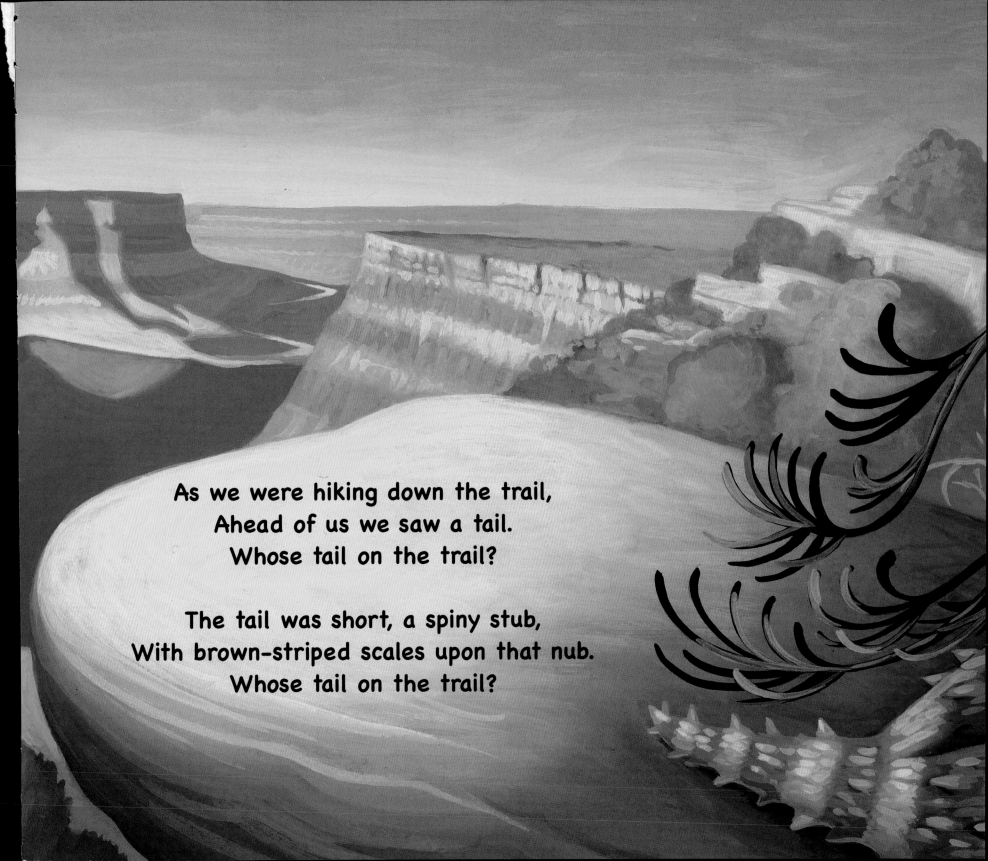

As we were hiking down the trail,
Ahead of us we saw a tail.
Whose tail on the trail?

The tail was short, a spiny stub,
With brown-striped scales upon that nub.
Whose tail on the trail?

Mountain short-horned lizard

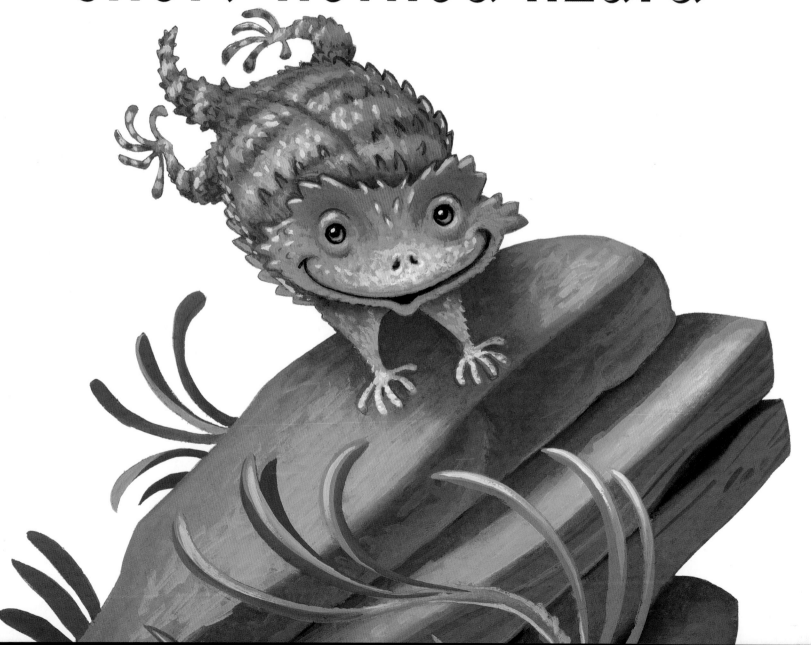

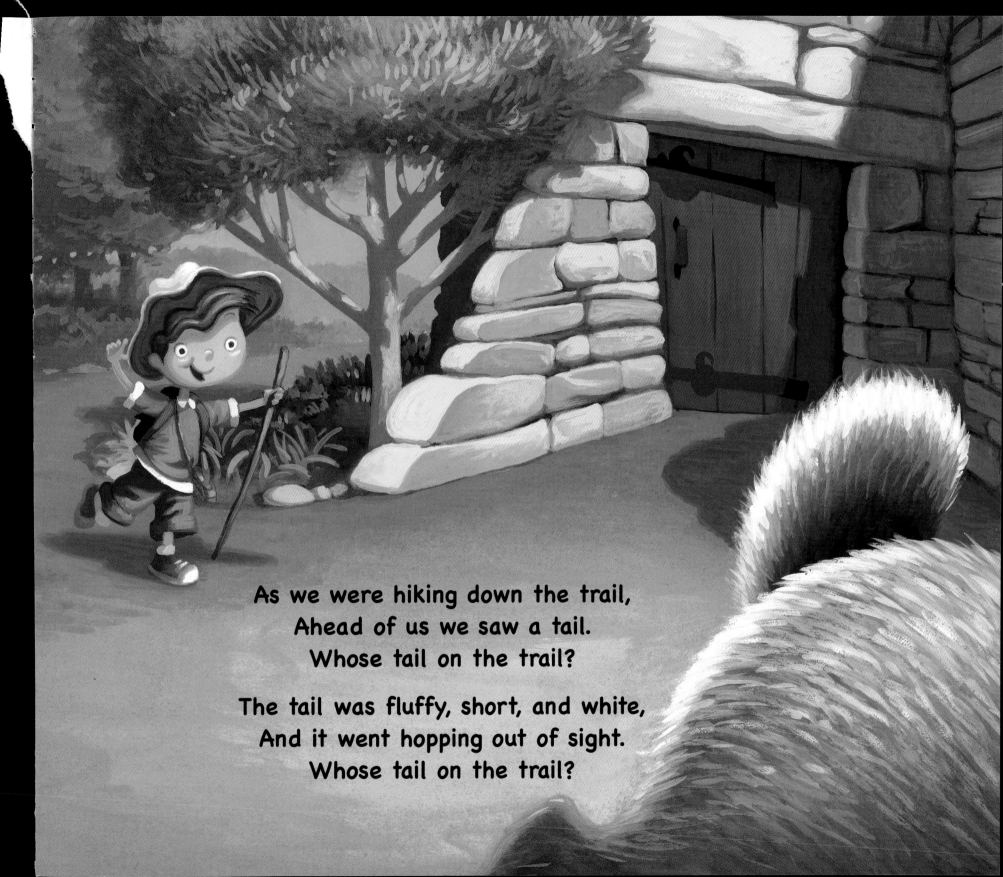

As we were hiking down the trail,
Ahead of us we saw a tail.
Whose tail on the trail?

The tail was fluffy, short, and white,
And it went hopping out of sight.
Whose tail on the trail?

Desert cottontail

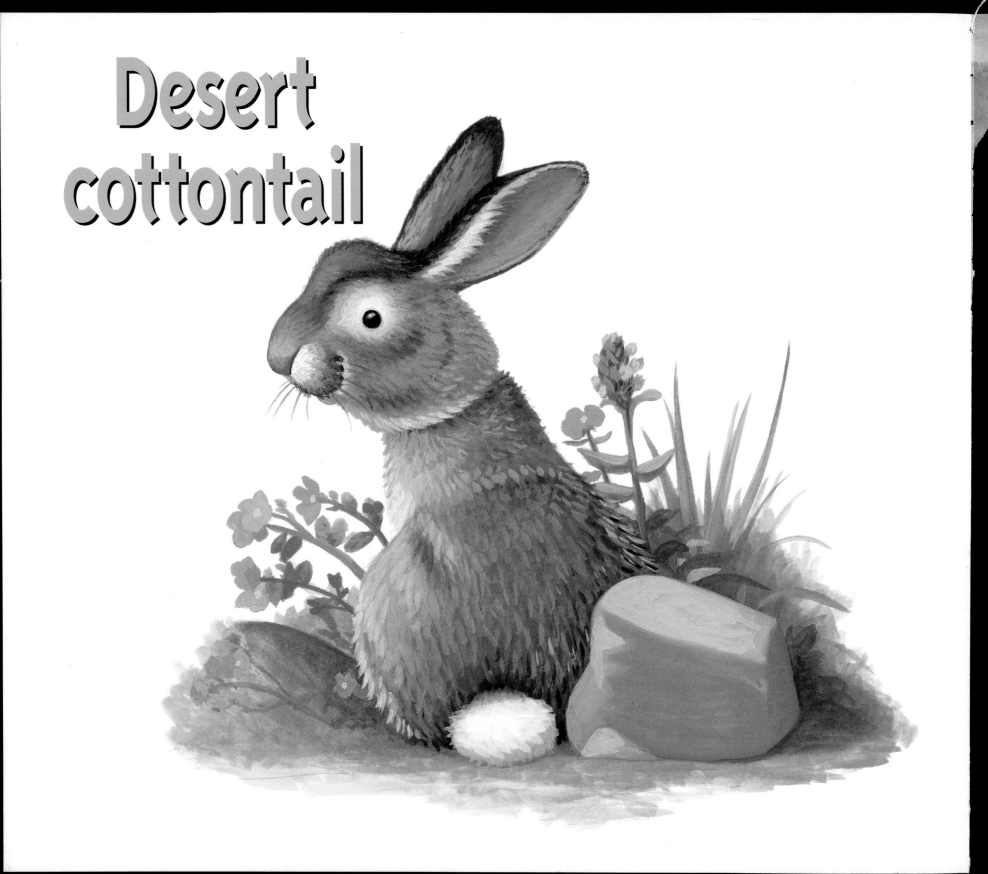

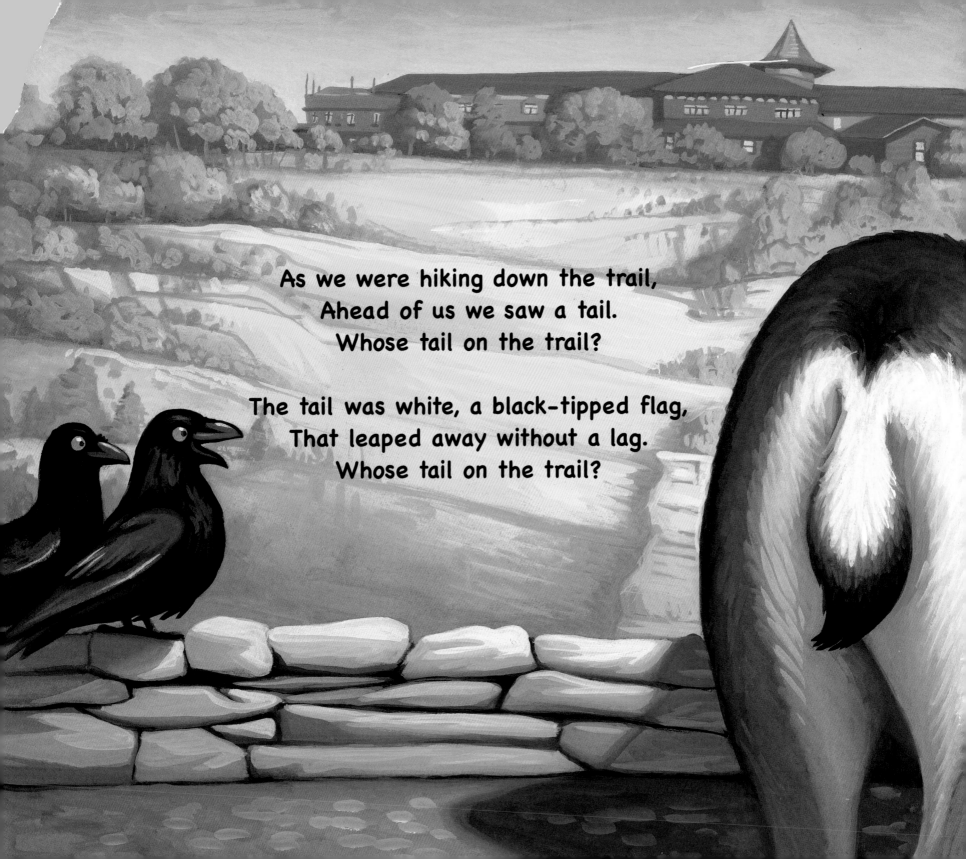

As we were hiking down the trail,
Ahead of us we saw a tail.
Whose tail on the trail?

The tail was white, a black-tipped flag,
That leaped away without a lag.
Whose tail on the trail?

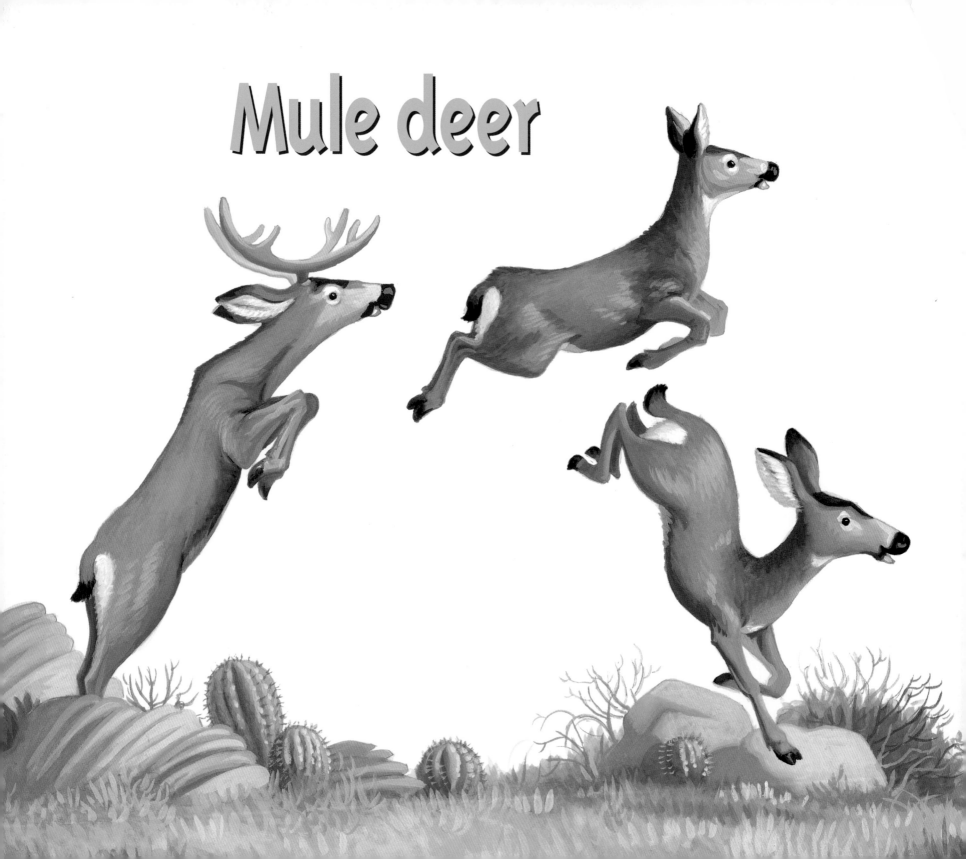

Mule deer

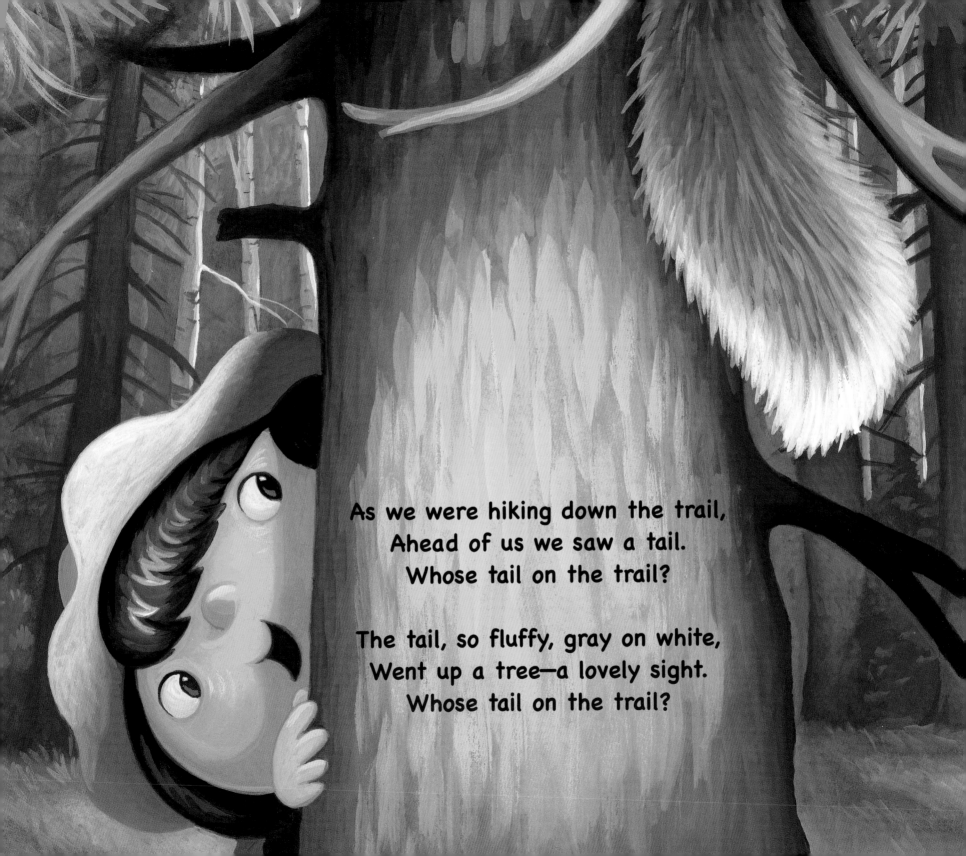

As we were hiking down the trail,
Ahead of us we saw a tail.
Whose tail on the trail?

The tail, so fluffy, gray on white,
Went up a tree—a lovely sight.
Whose tail on the trail?

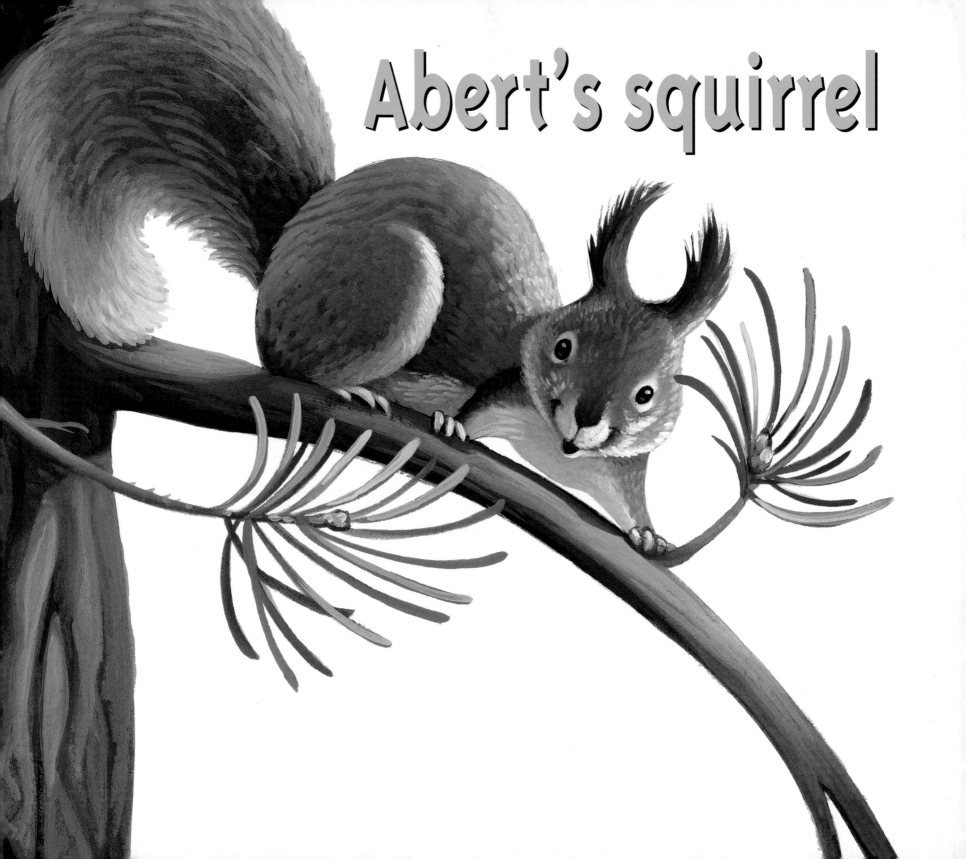

Abert's squirrel

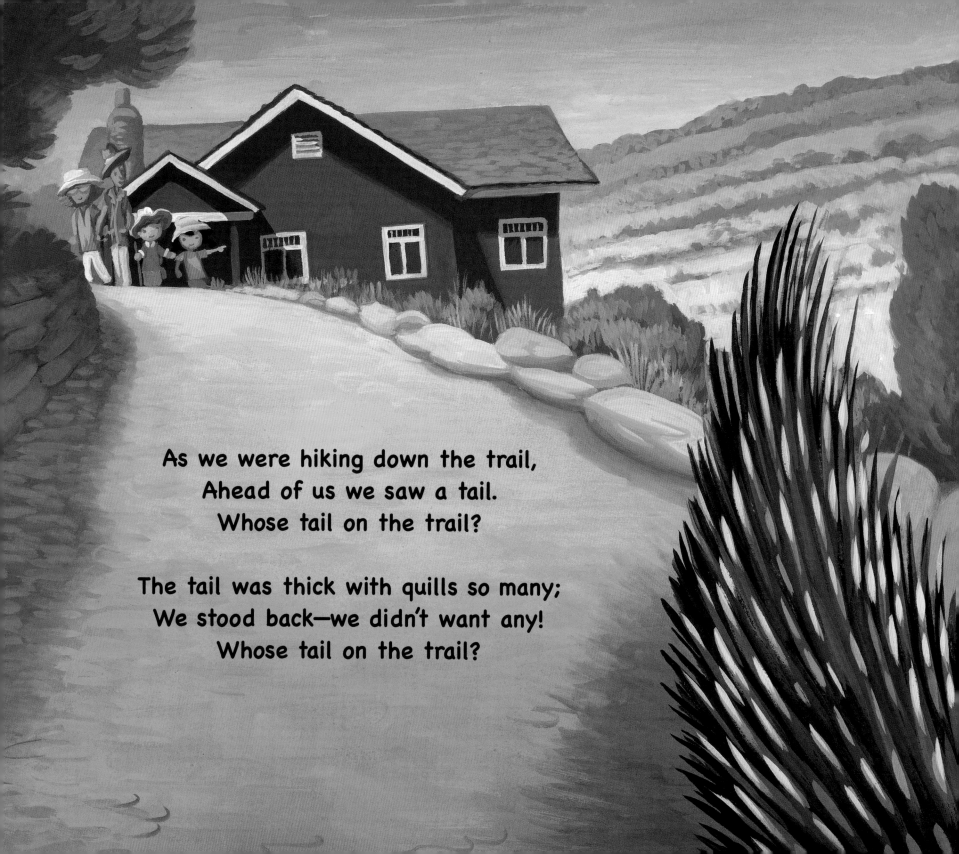

As we were hiking down the trail,
Ahead of us we saw a tail.
Whose tail on the trail?

The tail was thick with quills so many;
We stood back—we didn't want any!
Whose tail on the trail?

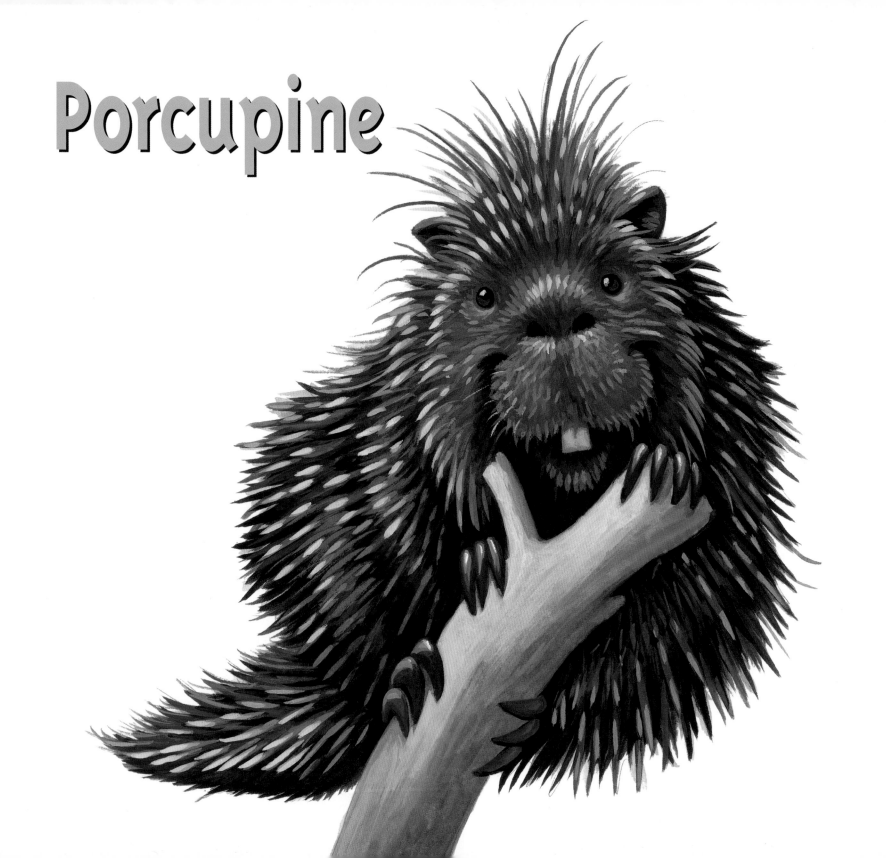

Porcupine

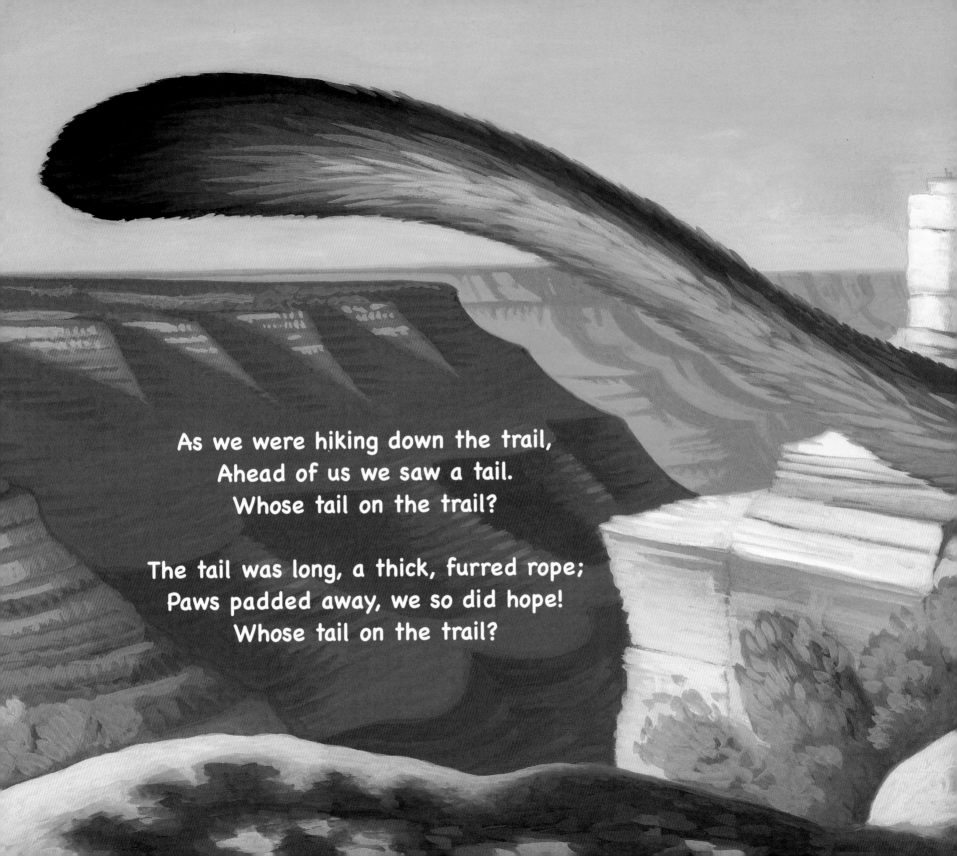

As we were hiking down the trail,
Ahead of us we saw a tail.
Whose tail on the trail?

The tail was long, a thick, furred rope;
Paws padded away, we so did hope!
Whose tail on the trail?

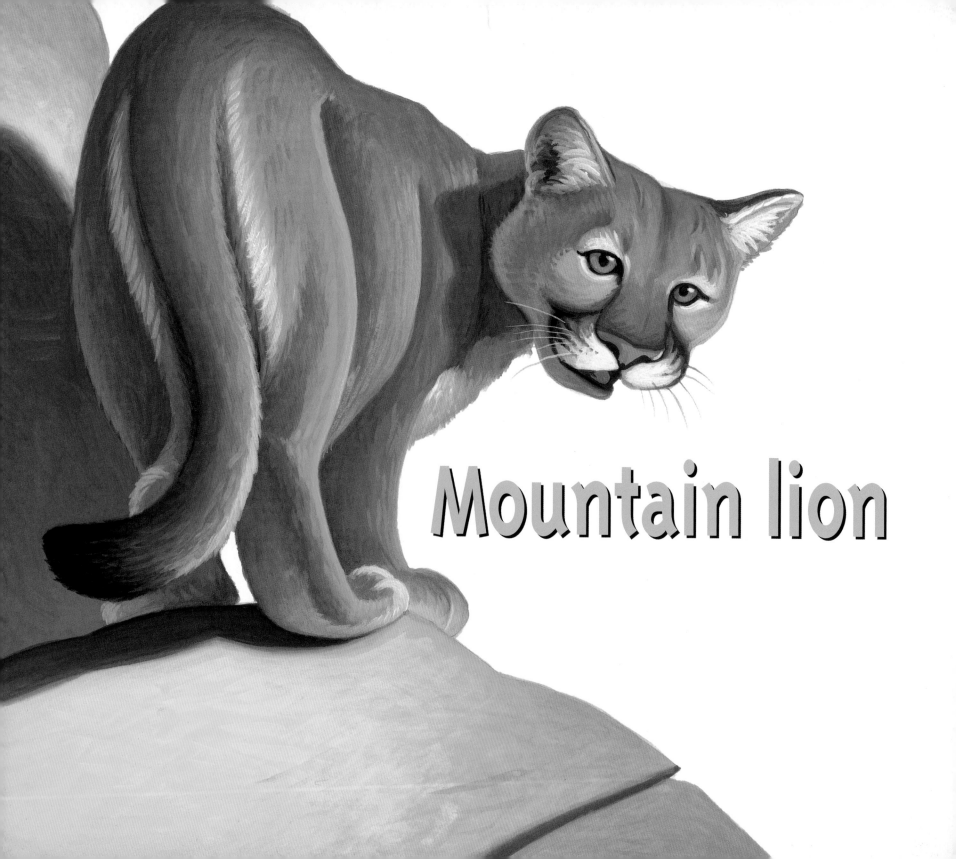

Mountain lion

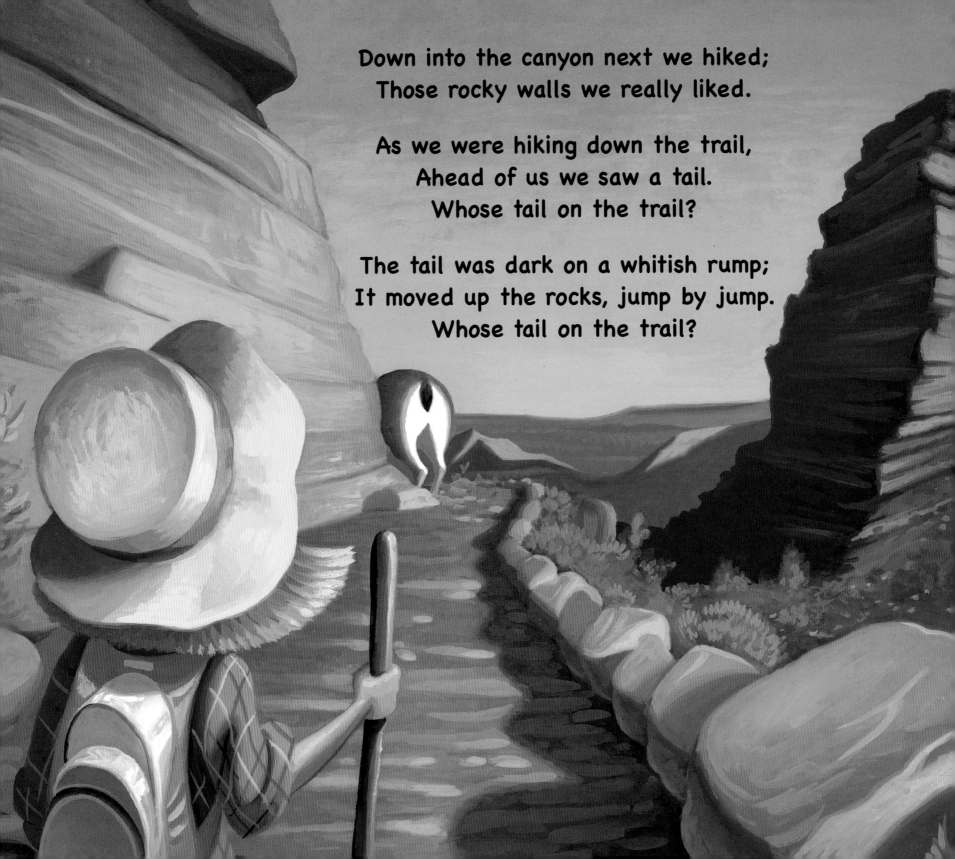

Down into the canyon next we hiked;
Those rocky walls we really liked.

As we were hiking down the trail,
Ahead of us we saw a tail.
Whose tail on the trail?

The tail was dark on a whitish rump;
It moved up the rocks, jump by jump.
Whose tail on the trail?

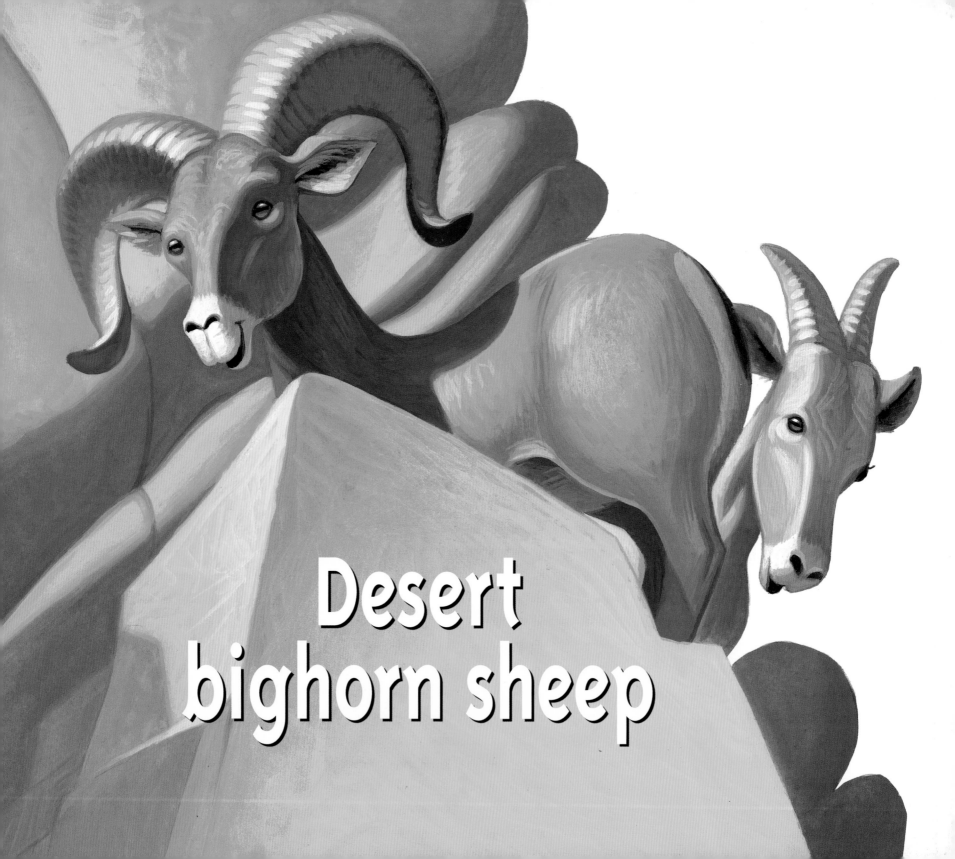

Desert
bighorn sheep

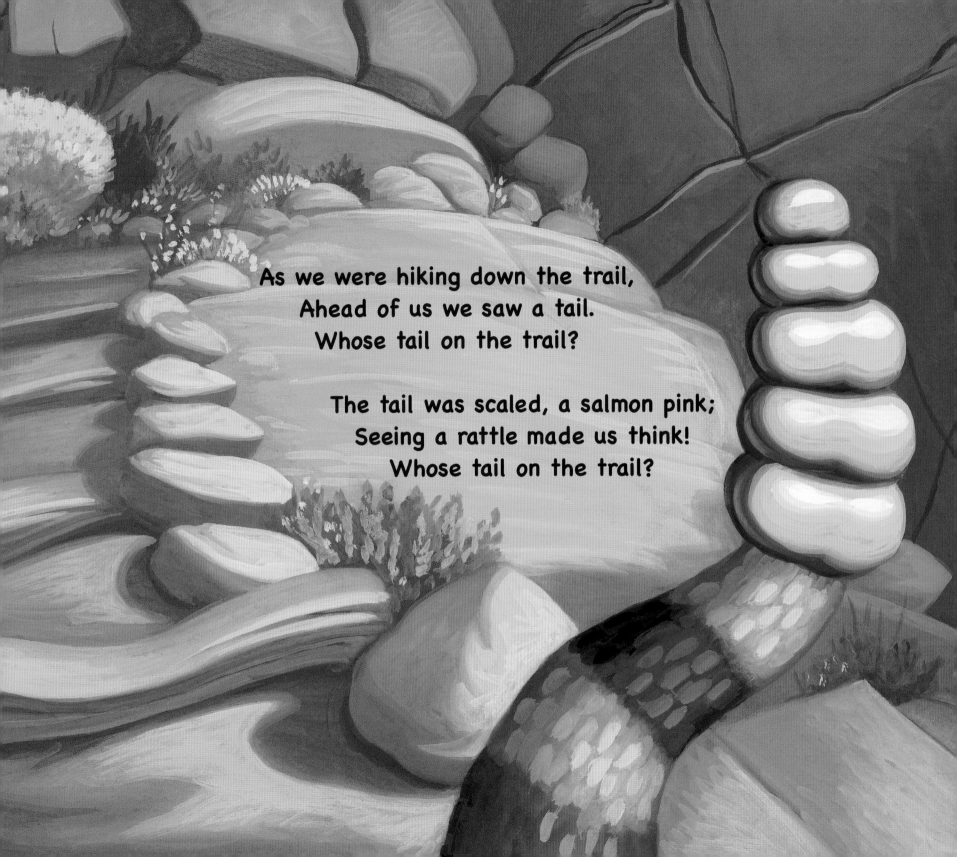

As we were hiking down the trail,
Ahead of us we saw a tail.
Whose tail on the trail?

The tail was scaled, a salmon pink;
Seeing a rattle made us think!
Whose tail on the trail?

Grand Canyon rattlesnake

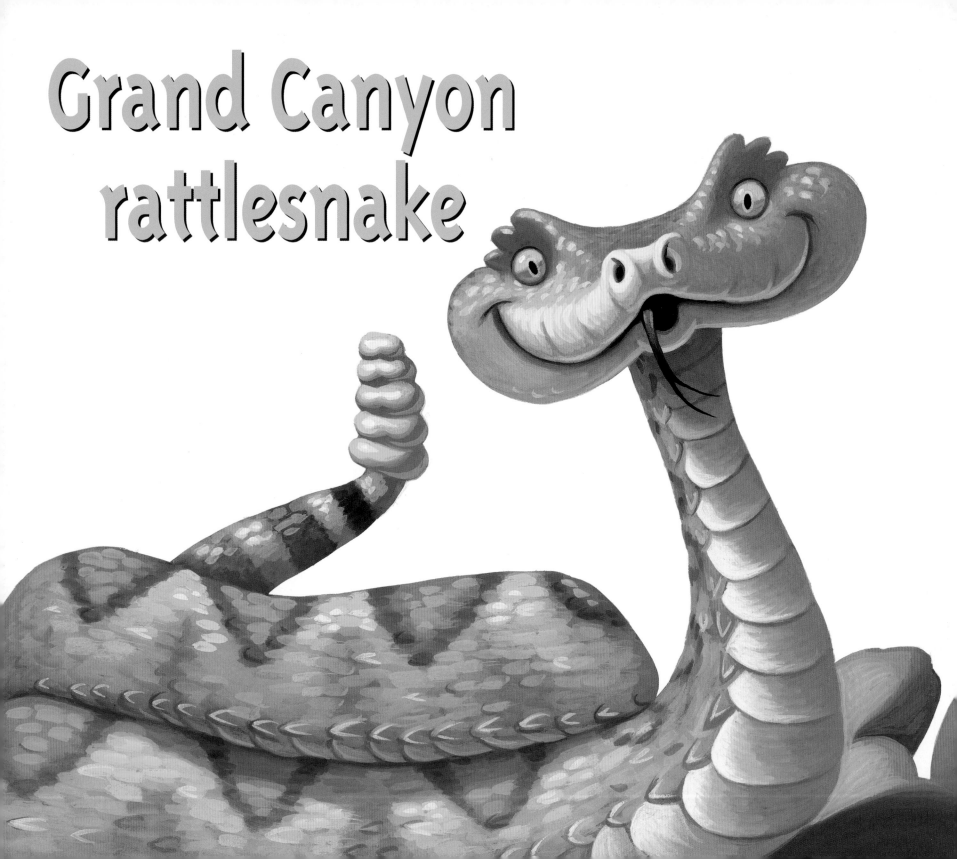

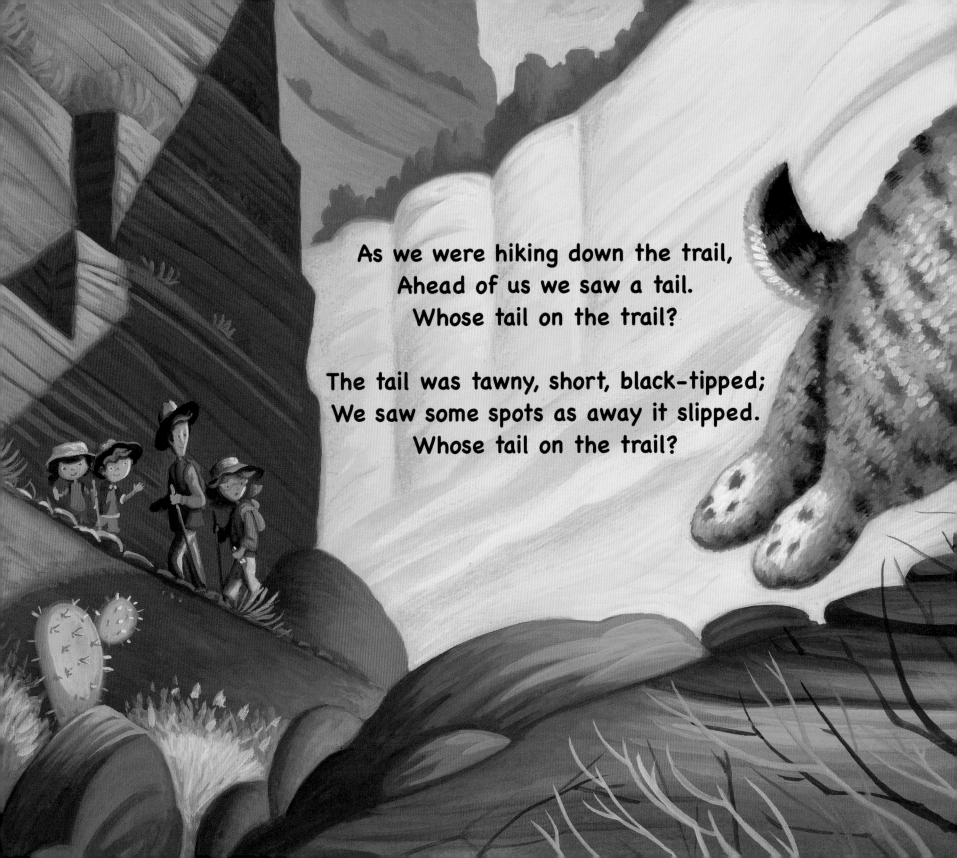

As we were hiking down the trail,
Ahead of us we saw a tail.
Whose tail on the trail?

The tail was tawny, short, black-tipped;
We saw some spots as away it slipped.
Whose tail on the trail?

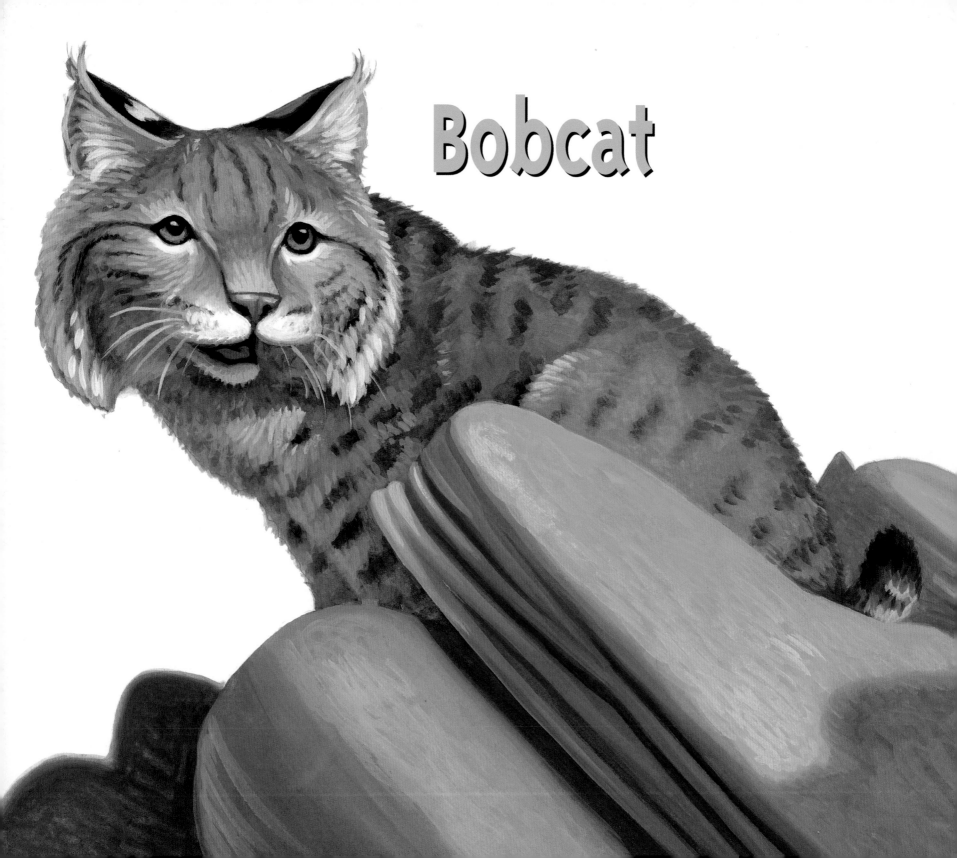

Bobcat

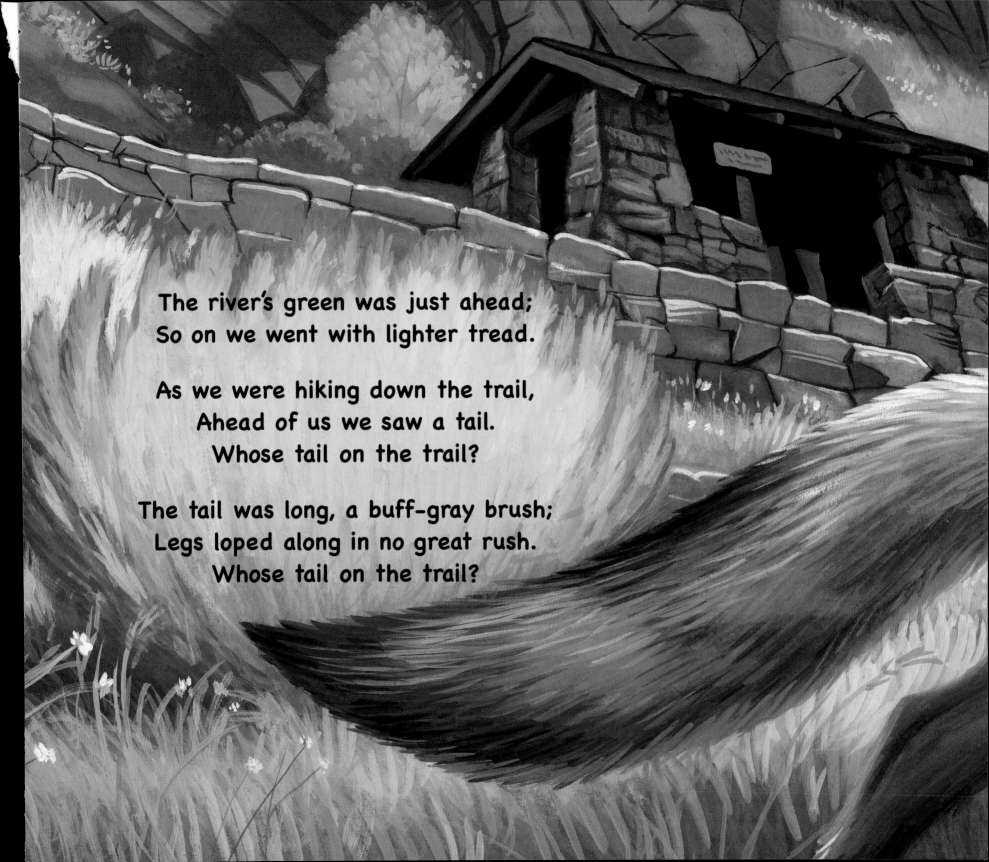

The river's green was just ahead;
So on we went with lighter tread.

As we were hiking down the trail,
Ahead of us we saw a tail.
Whose tail on the trail?

The tail was long, a buff-gray brush;
Legs loped along in no great rush.
Whose tail on the trail?

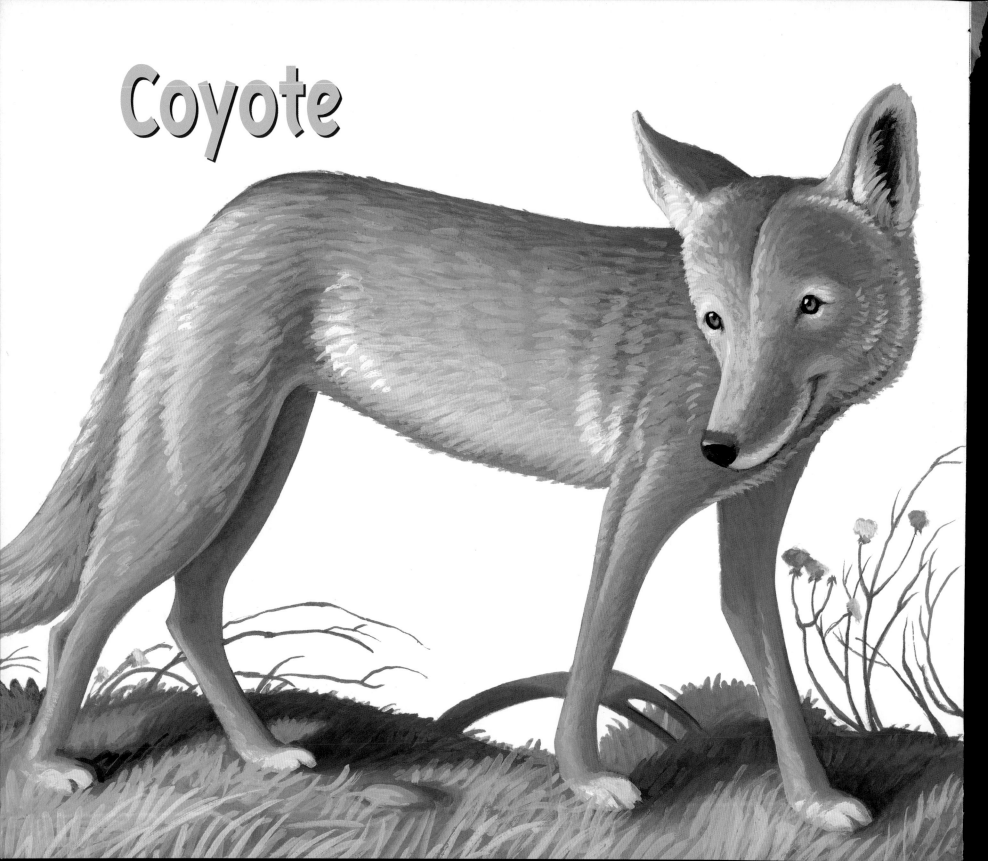

Coyote

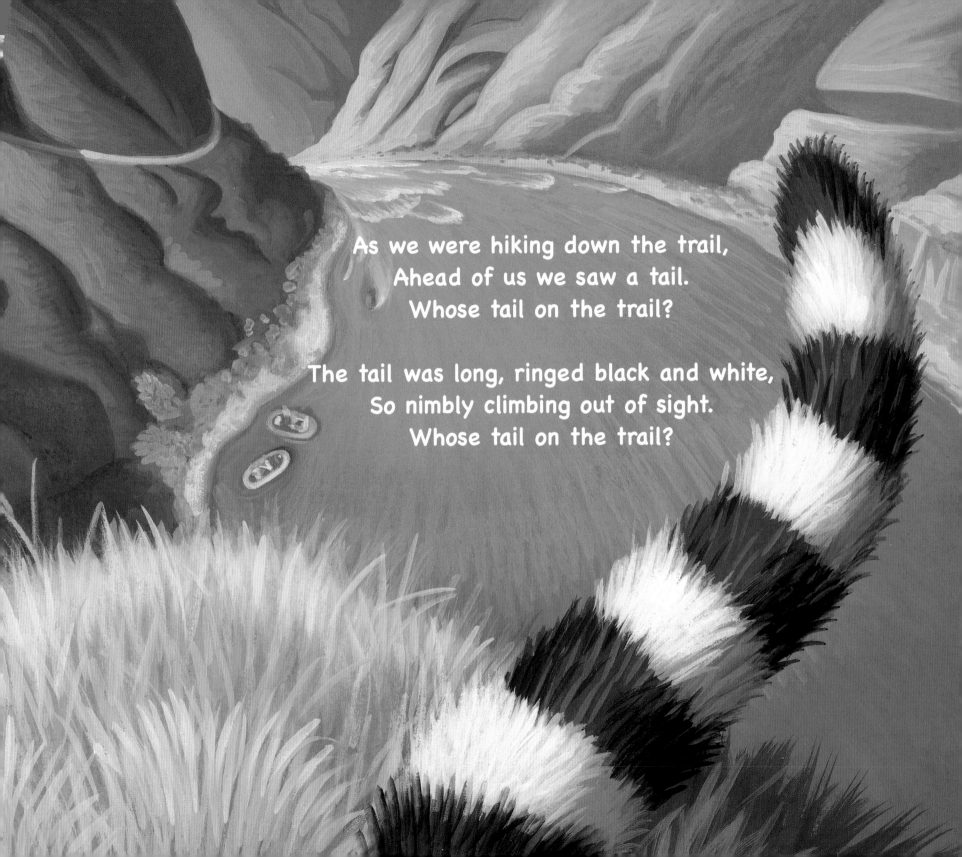

As we were hiking down the trail,
Ahead of us we saw a tail.
Whose tail on the trail?

The tail was long, ringed black and white,
So nimbly climbing out of sight.
Whose tail on the trail?

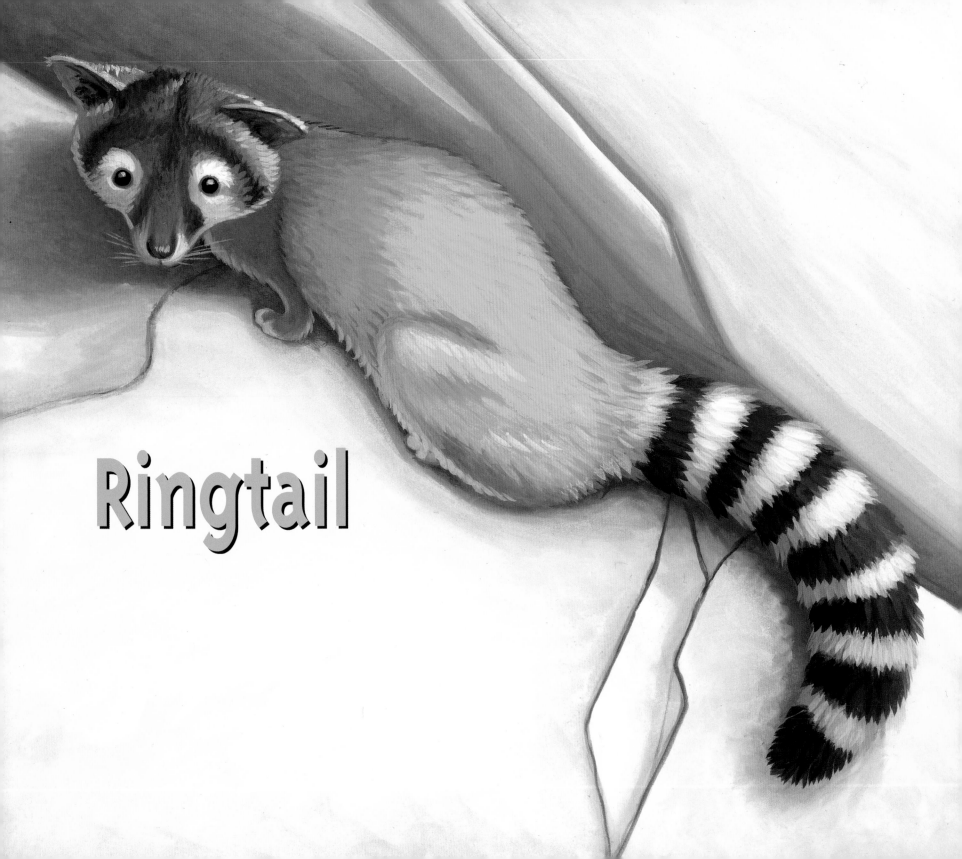

Ringtail

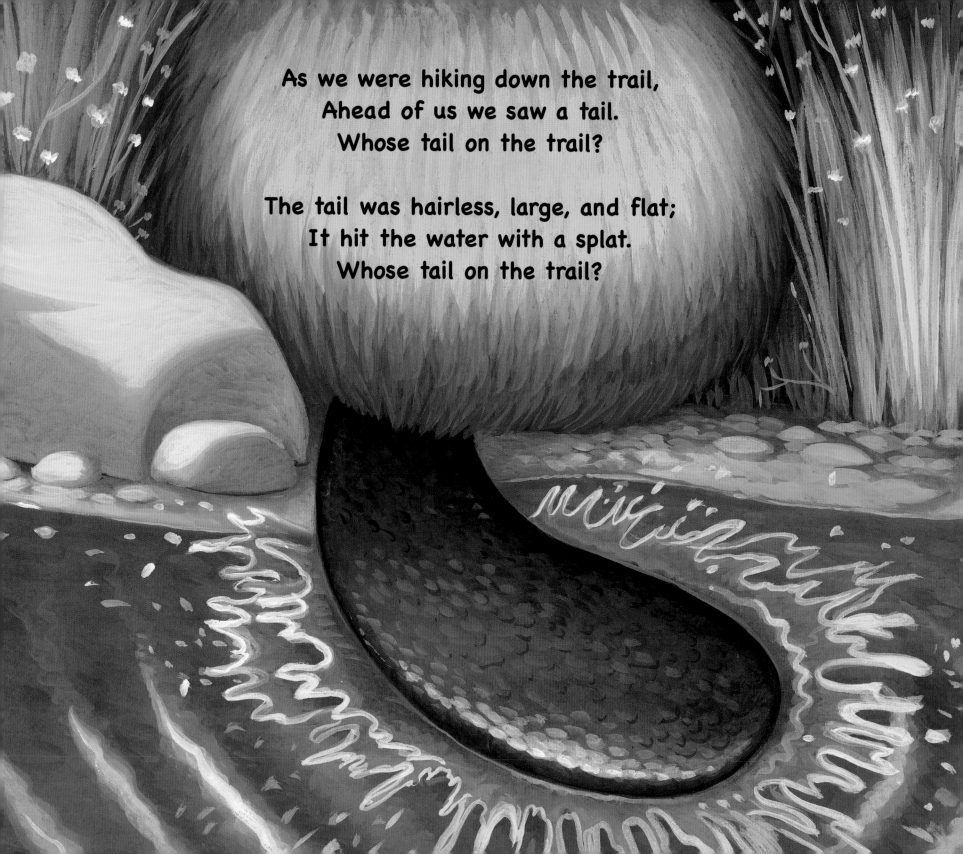

As we were hiking down the trail,
Ahead of us we saw a tail.
Whose tail on the trail?

The tail was hairless, large, and flat;
It hit the water with a splat.
Whose tail on the trail?

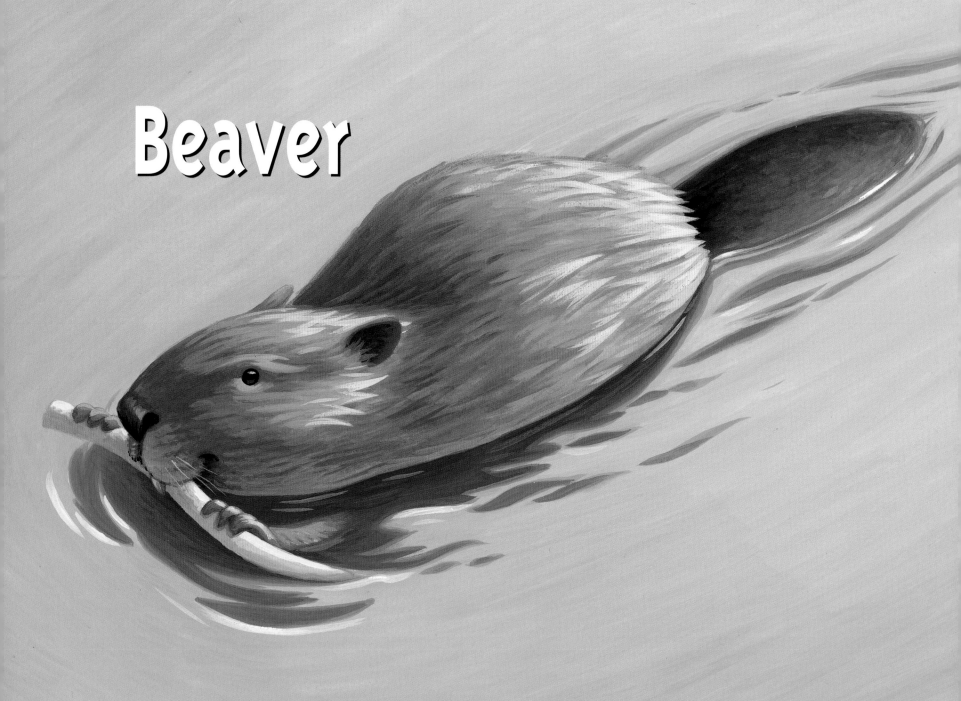

Beaver

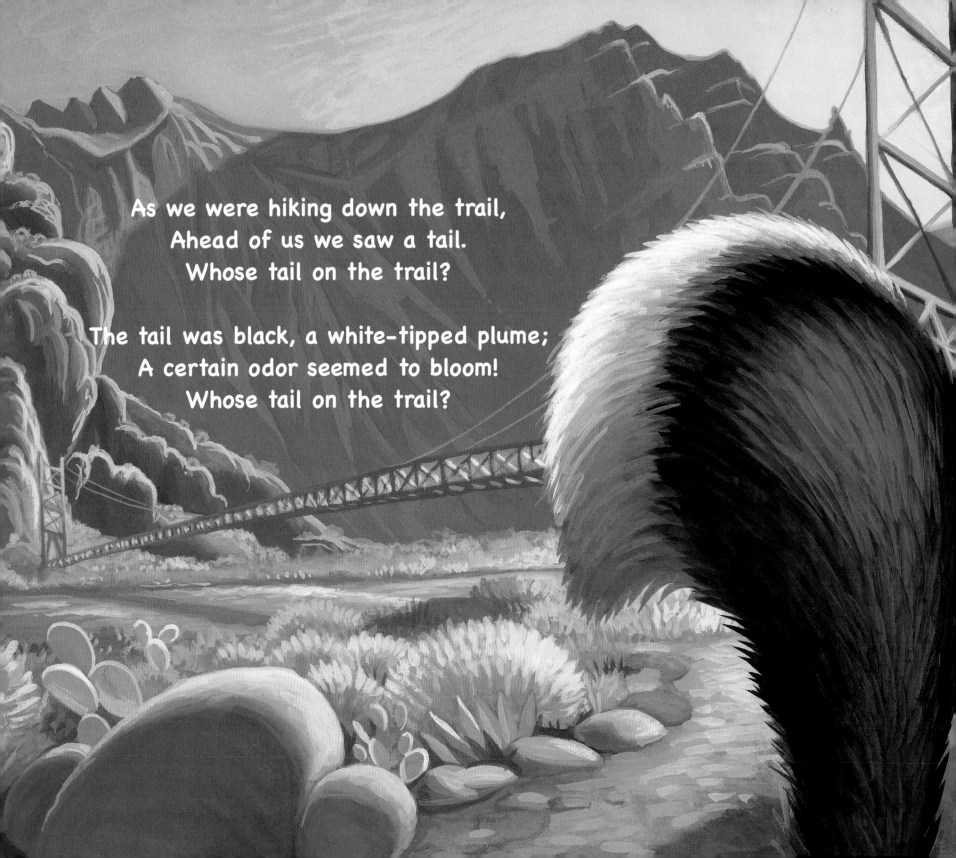

As we were hiking down the trail,
Ahead of us we saw a tail.
Whose tail on the trail?

The tail was black, a white-tipped plume;
A certain odor seemed to bloom!
Whose tail on the trail?

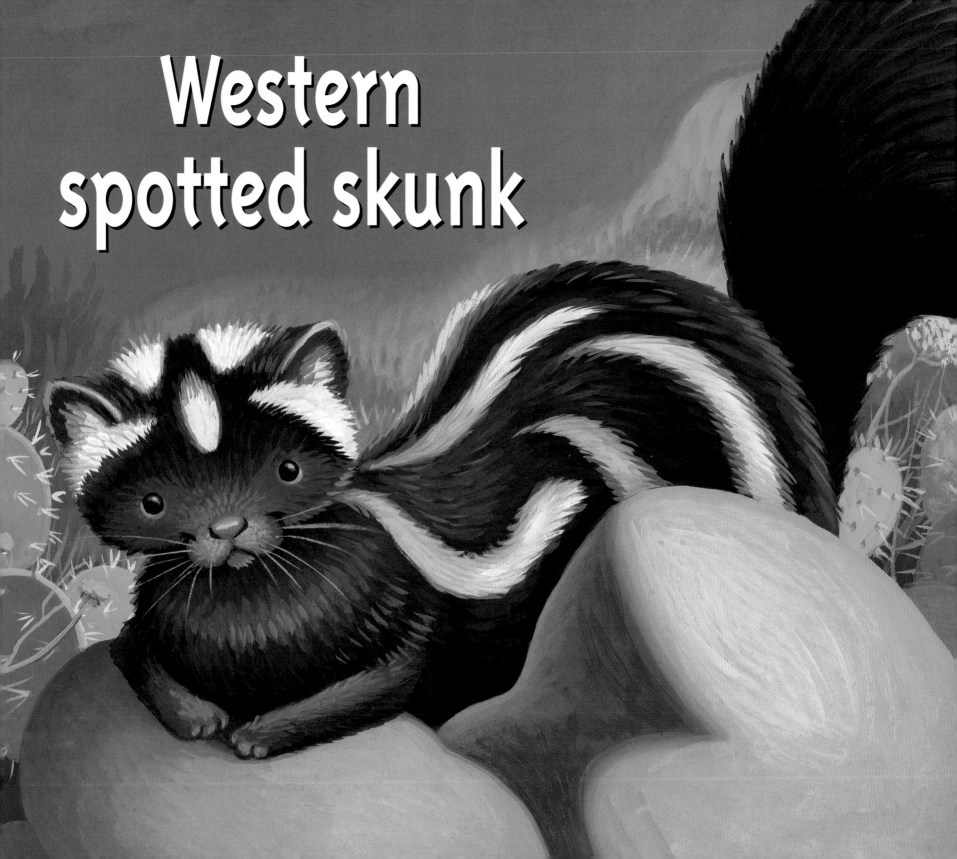

Western spotted skunk

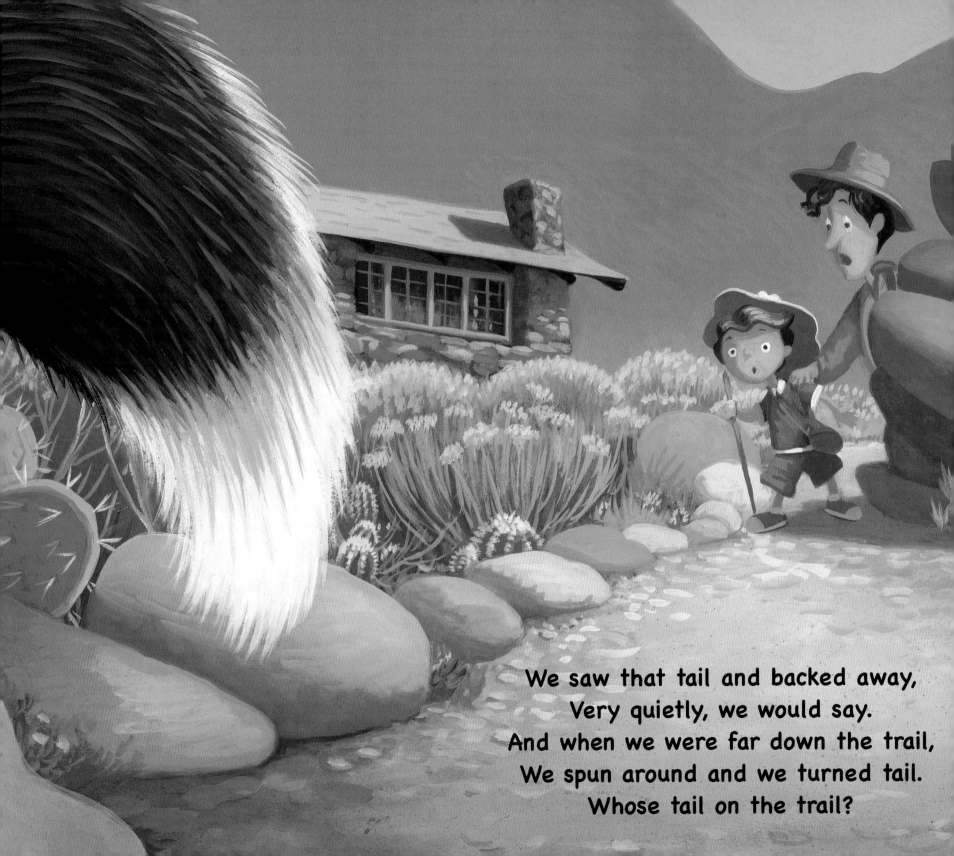

We saw that tail and backed away,
Very quietly, we would say.
And when we were far down the trail,
We spun around and we turned tail.
Whose tail on the trail?

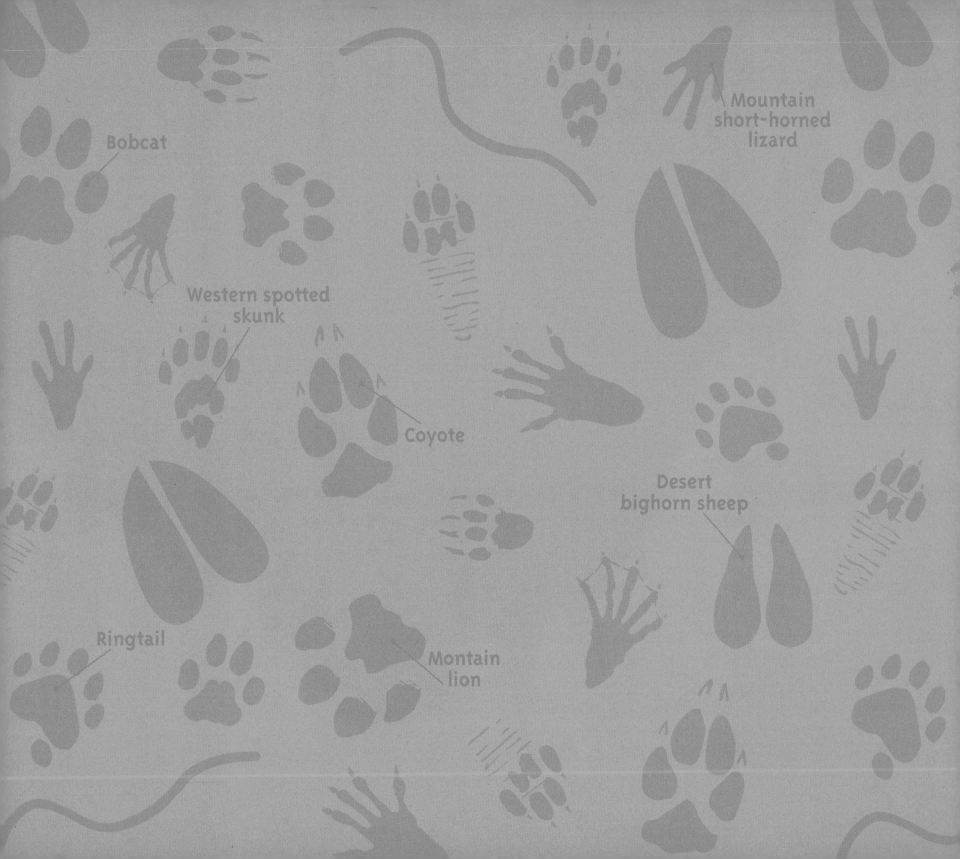

Bobcat

Mountain
short-horned
lizard

Western spotted
skunk

Coyote

Desert
bighorn sheep

Ringtail

Montain
lion